A CHILD OF GOD

A CHILD OF GOD

~ THE ENLIGHTENMENT ~

A story that tells us of God's love for all of his children
in keeping with the belief that his word shall free us
from the bondage in our mind, body and spirit.

By Lillie Sandridge-Hill

Keeping it spiritual, inspirational, and motivational
with a twist of humor is my dream in life.

iUniverse, Inc.
Bloomington

A CHILD OF GOD
The Enlightenment

Copyright © 2013 by Lillie Sandridge-Hill.

All rights reserved. No part of this book may be used or reproduced by any means, graphic, electronic, or mechanical, including photocopying, recording, taping or by any information storage retrieval system without the written permission of the publisher except in the case of brief quotations embodied in critical articles and reviews.

This is a work of fiction. All of the characters, names, incidents, organizations, and dialogue in this novel are either the products of the author's imagination or are used fictitiously.

All Scripture Verses Are From the King James Version Holy Bible

iUniverse books may be ordered through booksellers or by contacting:

iUniverse
1663 Liberty Drive
Bloomington, IN 47403
www.iuniverse.com
1-800-Authors (1-800-288-4677)

Because of the dynamic nature of the Internet, any web addresses or links contained in this book may have changed since publication and may no longer be valid. The views expressed in this work are solely those of the author and do not necessarily reflect the views of the publisher, and the publisher hereby disclaims any responsibility for them.

Any people depicted in stock imagery provided by Thinkstock are models, and such images are being used for illustrative purposes only.
Certain stock imagery © Thinkstock.

ISBN: 978-1-4759-7036-4 (sc)
ISBN: 978-1-4759-7037-1 (ebk)

Printed in the United States of America

iUniverse rev. date: 01/30/2013

This book is dedicated to my loving son and daughter

LESTLIE and DAWNDRA

ENLIGHTENMENT IS OUR KEY
TO BEGIN AND END OUR DAY IN PEACE.

CONTENTS

INTRODUCTION ... xi

ONE	WISHFUL THOUGHTS	1
TWO	DREAMTIME ..	5
THREE	HEAVEN AND EARTH	9
FOUR	BUTTERFLY WINGS	13
FIVE	COLOR OF LOVE ..	17
SIX	SACRED MOMENTS	21
SEVEN	THE FIRST 63 YEARS	25
EIGHT	BY THE GRACE OF GOD	29
NINE	HEALING ...	33
TEN	POWER OF LOVE ...	37

INTRODUCTION

A CHILD OF GOD: The enlightenment is a book about love, and the hopes and dreams of the many people who live on our planet earth and the belief that God's love for all of us will transcend any partition that keeps some people separated from each other. Ask God for his blessing on the endeavors you take in life and your path will be enlightened in the direction you should go in. I believe all of God's creatures dream the dreams of life. Therefore, we should live with the knowledge that God does love us all because we are all God's children in this world, and his love will show us the direction we should be going in our daily life of destinations. As always may God bless our journey.

> The Spirit itself beareth witness with our spirit that we are the children of God: And if children, then heirs; heirs of God, and joint-heirs with Christ; if so be that we suffer with him that we may be also glorified together. For I reckon that the sufferings of this present time are not worthy to be compared with the glory, which shall be revealed in us.
>
> Romans 8: 16-18

ONE

Wishful Thoughts

When we are young and show promise of wonders to come: life is good for those who wish upon a star to be all they can be in life. The parents wish is for their child to have a happy, healthy long life of joy and prosperity. The well of wishes grows as we grow; for all of God's children have his love no matter which direction they may go, and prayers go out to the heavenly father each day by someone who loves you and cares in which direction you go. Never miss a day of prayer to guide you or a love one on a path that adds a blessing to theirs or your day. Even as our youthfulness fades we still have wishful thoughts of hopes and dreams that we pray will still come true. As we grow older our wishes grow dim, but never forgotten just laid aside like a toy we loved but never picked up again. Wishful thoughts: a place where hopes and dreams lie and where God listens as our wishes turn to prayer.

There once was a young man who was not born into a life of privilege, but a life destined for great things if he strived in the direction of God's will to make his life a good and blessed thing for himself and others. He often thought of others in the most kind and thoughtful ways. He often

thanked his mother for raising him to be the soul that he as an adult man is today; knowing that his mother's love watched over him along with God's love for all his children through thick and thin. When we wish upon a star as children: we wish for things not yet seen but hoped to be. Life changes things from time to time, but in our heart we must stay close to God if we expect our life to be a life befitting our father's love. The wishful thoughts, or just wishing upon a star is just a childish desire for things not earned, and will not earn us the things we desire in life without the grace of God's love, and faith in him to guide us in our many endeavors on life's journey.

When this young man grew in God's love his life took on a meaning of self-worth and credibility in his accomplishments that made him a joy unto his mother's love. Wishes never come true unless we live the life that shows obedience to God. No one is perfect but we can always, and I do mean always come to God in prayer, and he will listen with open arms to our desires and even our cry for help in understanding any of the situations we may find ourselves in, and guide us in the direction we should be going. Remember, everything happens for a reason. I do not believe God picks each of his children out randomly to be blessed, but I do believe he does expect some effort on our part as a child of his to be worthy of his blessings. When someone appears more blessed than you: think of this and remember Jesus words that it is more blessed to give than to receive. So do not worry about what you do not have. That ye might walk worthy of the lord unto all pleasing, being fruitful in every good work, and increasing in the knowledge of God (Colossians 1:10).

Wishing upon a star to guide you through life is a precarious way of accomplishing your hopes, and dreams, and will certainly not give you the grip you need on your journey through life to show your love and obedience to God. Life is hard work as we all know, and some people who are not happy with theirs can make it even more difficult for others. Job endured and happy was he when blessed for his patience, and his love for the Lord. I'm sure you have seen or met people in your every day life that can make living uncomfortable for each person who crosses his or her path. These people are very unhappy with their lot in life, and walk through each day with visions of grandeur to try and hide the unpleasant feelings of the inadequacy of their own hopes and dreams that have failed to materialize so far in their own life.

A Child of God

Wishful thinking is not a waste of time, because this is where life begins to show us the road to the ideas that we have in our mind. God can guide us in the right direction when we ask for his guidance, and just because your dreams have not yet come true might be God's way of telling you in time maybe when you have grown more and have obtained more wisdom, and understanding these things might come true for you. Wisdom is the principal thing; therefore get wisdom: and with all thy getting get understanding (Proverbs 4:7). All of God's children know that he loves them always no matter their education or wealth, and they are not jealous of the people who may have these things: because they can come and go in time, and that is the reason God's love for his children, all his children is evident in those who choose to grow in wisdom and understanding of his word.

Let me tell you of a story called the wishing well plight (truth in life inspired). Many people including the young and old came to this wishing well everyday to make a wish in this small dusty California town where a wishing well stood on top of this steep rocky hill. One very pleasant day no one showed up to make a wish. This went on for weeks. Soon the wishing well became afraid that everyone had begun to disbelieve in his work, so he was very afraid that his time had come to dry up, and be covered in dust. Then one day the wishing well decided to take matters into his own hands and visit each town person in their dreams at night to see if he could get them interested in coming to see him again. Night after night with no avail he could not penetrate not even one person's dreams to coach them back again, and so he decided to try one last thing.

Since he was the great and mighty wishing well he decided he would make a wish for himself. Knowing that if he could grant other people wishes certainly he could grant his self a wish, and so he did. He wished of course that people would visit him again, believe, and trust that he could make their dreams come true. The people still never came back. What the wishing well did not know is that to make a wish you have to have faith that the wish will come true. Faith comes from God when we believe in him. So the wishing well plight was solved when he realized that people had not forsaken him, but had always put their faith in their salvation with the lord, and it was not him they trusted for their hopes and dreams to come true: just a game that people played to entertain their thoughts while they prayed, and waited for God's blessings as they worked their way through their life.

Sometimes it is not just believing in yourself, but who believes in you, and you believing in them. When you believe in God he believes in you. The wishing well days were numbered as all ours are, but he was just not aware that his time had come to move on to another realm. The mouth of a righteous man is a well of life: but violence covereth the mouth of the wicked (Proverbs 10:11). Living your life to be a blessing to others can be the most fruitful way to see your wishful thinking come to life. Even if the wishing well has moved into another realm in our mind; the wishful thinking will always lie within our heart as we pray to God that he grant the wish that we wish tonight. May God bless you, and keep you safe in your journey of hopes, and dreams through your life's many pathways of wishful thoughts: that will help you, and others that you meet in this world.

TWO

Dreamtime

Dreamtime is the time we spend dreaming dreams may we be asleep or awake. For this is the time when we imagine our life in different aspects of what is unrealistic to the possible. Dreams can be a communication that reaches out to us from God, or God's way of helping us relieve daily stress. Dreams can put things into perspective that we may or may not understand at the time, but will always give us the insight that we should acknowledge what is going on in our lives. Sometimes living in this world can dampen your spirits when your dreamtime of seeing your future in a positive light is hampered by people who would like to control and micro-manage your life in ways where they feel inadequate, and unsure of their own future. If common sense and experience has brought you through many storms, it is because of this and the good graces of God that has kept you from harm; stick to what you know. Do not let other people fears control your life. So that we may boldly say, The Lord Is My Helper, And I Will Not Fear What Man Shall Do Unto Me (Hebrews 13:6).

God loves you. Embrace his love, feel his love and show your love for him in your daily life. You will not always feel the love from everyone that

passes through your life. However, you will feel God's love when you show obedience to his word. God loves all his children. Some people would lead you to think that some people are special in this world and some are not so special. Never doubt his love, and remember there is a reason for everything, which will be revealed to us at a later, but sooner than you think date. Dreamtime is your time and we are all capable of dreaming, and all of us are his special children with different talents. So dream the dreams of life, and live your life to the fullness in his namesake. For God so loved the world, that he gave his only begotten Son, that whosoever believeth in him should not perish, but have everlasting life (John 3:16).

There will always be people in this world who will look forward to cutting your dreams up into little bitty pieces: of course sometimes when a person intention is to hurt or defame you, can be a twist of fate and bring you into a glorious beginning of fame that will expedite your dreams into reality (some people say God works in mysterious ways, I say his ways are evident to his word). For jealousy is the rage of a man: therefore he will not spare in the day of vengeance. He will not regard any ransom; neither will he rest content, though thou givest many gifts (Proverbs 6:34-35). Never let your dreams perish like a puff of smoke. Satan does have his followers, as does God. When life throws you a curve ball, which it will from time to time, be inspired to do your best and just keep moving in the direction of the Lords light. When life comes at you hard, and is very difficulty to digest; give yourself continually to prayer and read your bible for spiritual food to keep you sustained in a famine world.

Dreamtime is the best time for growing seeds of spirituality, inspiration, and motivation to share with those who would like and those who are now trying to keep their life's journey in the pathway of the Lord's light. The messages I give is to help those in real life deal with real problems that plague us in this realm of every day living situations that we encounter daily with others on their journey beside us. For all those who truly believe in God and his spoken word, listen and watch your life be enhanced with God's love, and mercy for his children. May you be awake or asleep when you dream the dreams of life. Always remember that God loves us all, and it is we who treat our fellowman with bias. Love worketh no ill to his neighbour: therefore love is the fulfilling of the law (Romans 13:10). Bless be the word of God that leads us on a journey of salvation to those who seek it's meaning to life.

A person seeking the love of God can be married, single, divorced, in prison, not in prison, or just be imprisoned in their mind may they be young or old alike. Look no further for God is always at your side in life, and you know he loves you if he gave his only begotten son so that you may live. He never leaves you, you leave him when you stop believing in his word. Stay strong my friend for this is what Satan wants is for us to falter in life so we can be with him in his army of liars and deceivers of humankind. Dream your dreams of a good life free of Satan's grip. Bad things will not ceased to happen, but with God at your side he will keep you strong when weathering any storms you may go through. The Lord is my strength and my shield; my heart trusted in him, and I am helped: therefore my heart greatly rejoiceth; and with my song will I praise him (Psalm 28:7).

We all know people who can make life more complicated than it has too be. This should not slow you down though, so when life throws you an obstacle in the middle of your path, pray and then leap over it. Remember you do not want to keep Misery Company. When God made the universe he had a dream in mind that would kindle the beginning of humankind journey into a world of truth and lies. The good thing is that his love for us, his word to guide us, and sending his only begotten son to save us from our iniquities gives us the tools we need for our salvation. You cannot get a better deal than that. Anything else would cost you. So hold onto your dreams and believe that the one and only true way to your salvation is through Jesus Christ. I think we all should know by now that the only way to the father is through the son.

Life is but a dream I have heard, I think not. Life is a reality check, and reality bites; and when it bites you, you feel the pain. Smile! God loves you! You have to stay agile to accomplish your dreams in this world that we live in, and believe in your creator's dreams for you. God only wants the best for you. Who else do you know of that has your best, and only the very best interest in your survival, and has shown it by their actions and not just their words? I am an advocate of God's word; which has helped me to grow stronger and wiser to this world's everyday problems, and what God needs from me. Things have not always been this way for me, but I am glad that I woke up before it was too late. I still have a very long way to go, but it does help me to understand, and pray for understanding of things that I thought I knew, and did not know. Remember there will always be someone around working for Satan to look and fine a way to

your demise, but do not, I repeat do not let evil ways suck you into a life of damnation (resist Satan).

My final words on dreamtime is this. Every good gift and every perfect gift is from above, and cometh down from the Father of lights, with who is no variableness, neither shadow of turning. Of his own will begat he us with the word of truth, that we should be a kind of firstfruits of his creatures. Wherefore, my beloved brethren, let every man be swift to hear, slow to speak, slow to wrath: For the wrath of man worketh not the righteousness of God. Wherefore lay apart all filthiness and superfluity of naughtiness, and receive with meekness the engrafted word, which is able to save your souls, But be ye doers of the word, and not hearers only, deceiving your own selves (James 1:17-22).

THREE

Heaven and Earth

Your life's journey began here on earth, and so your destination should be heaven bound where Jesus Christ awaits you. My father once told me there is no such thing as luck and that each good thing that happens to you is a blessing from God. To partake in the blessings of the Lord here on earth and to be continued in heaven we must live our lives in the light. Lay not up for yourselves treasures upon earth, where moth and rust doth corrupt, and where thieves break through and steal: But lay up for yourselves treasures in heaven, where neither moth nor rust doth corrupt, and where thieves do not break through nor steal: For where your treasure is, there will your heart be also (Matthew 6:19-21). Our Lord name is excellent in all the earth that has set his glory above the heavens. Neither is there salvation in any other name under heaven given among men, whereby we must be saved. We are all God's children, and all his children will seek his word to receive his blessings on earth and in heaven.

As children of God we should abide by his word and notice that when we do, life takes on a different meaning on how we conduct ourselves among others in our daily living, and how we can ease our burdens simply

by understanding people and why they do what they do. As a child of God, your faith in him shall reign over any disbelief of him on this earth. My little children, let us not love in word, neither in tongue; but in deed and in truth (1 John 3:18). Your belief in God will carry you through many storms, and will set you free to enjoy your life here on earth, as it should be. Your mind and spirit will be free to live a life of serenity when you keep his commandments, and do things that are pleasing in his sight. The world may hate you, but remember Ye are of God, little children, and have overcome them: because greater is he that is in you, than he that is in the world (1 John 4:4).

God's love for all his children here on earth and in heaven is shown to us in his word. His word leads us down a path of righteousness and understanding of what he wants and expects of his obedient children. His guiding light enlightens our pathway so we may see clearly the road we travel. Sometimes we step off the lighted pathway that God has laid before us only to fall down and regret our decisions later on in life. Asking God for forgiveness is not a weakness, but a sign of acknowledgement of his everlasting love for you. When we see people going in a direction that will ultimately be their demise if they continue on this way: we talk to them and let them know how much we love them. We pray for them and even try to persuade them to stop before it is too late. As always the choices we make, and the direction we go in will determine which home we go to at the end of our days here on earth.

Love is a powerful emotion that can lead you into heaven or hell. Are you here on earth as a child of God or a child of Satan? Whom do you love? The things we do; the way we treat each other in life shows who, and what we love on this earth, and what worldly things we love more than our eternal soul. Since we were all born into sin and no one is perfect we must come to the lord in prayer to keep our body and mind strong in his word for our salvation. Jesus once said to his disciples whosoever will save his life shall lose it: and whosoever will lose his life for my sake shall find it. For what is a man profited, if he shall gain the whole world, and lose his own soul? Or what shall a man give in exchange for his soul? (Matthew 16: 25-26).

Satan is among us, and he is working hard to obtain as many souls as he can before he meets his own demise. When we let him control our movements here on earth and enter our thoughts, we give him reign over our eternal life. When you know his trickery; you can deal with his lies of

A Child of God

persuasion as an annoying fly that you just want to be rid of it's presence. Some times it may be hard to calm yourself when you are truly irritated by something or someone who has definitely rubbed you the wrong way; and you might even speak before you think, but try not to let your emotions get in the way: for this is Satan's influence over you. A door that you just opened and let him enter. When you stop and gather your thoughts on the matter, you can pray over the situation at hand and regroup with a clear mind. Remember prayer helps to keep the debris from clouding your mind and keeps your pathway clear of clutter.

Reading your bible will help you to understand yourself and others, and will open up your eyes to God's intention for all of his children who worship him. Ask the lord for understanding of his word. Even as children, we know right from wrong. Following the word of God can only lead you to a place of peace and harmony, which is a lot better than that other place I am sure. I know some days are harder than others, but think about where you want your eternal soul to rest. When we are young, we feel as though we will live forever until we approach that age of reasoning, and then we began to realize how short life really is. As I always say better late than never. So search for the lighted path that leads you to our Lord and savior. You can free your mind of earthly matters when you trust in the Lord. Watch as you overcome each obstacle that life throws at you when you know that the Lord is at your side.

You can go to church every day, read your bible every day, and pray every day, this is good, but it will not save you unless you have faith in God and believe that our sins were washed in the blood of the lamb Jesus Christ who died for us so that we may be free to enter heaven if only we believe in him, trust and live by his word. Ask for his guidance to keep you on the path to the stairway to heaven. The division between hell, earth and heaven are but a thin line, so all I am just saying is be careful where you step. This is not to scare you, but to let you be aware of all things that looks good to the human eye here on earth, but are laden with the trappings, and the smell of a snake named Satan. As you have probably heard, one of Satan's biggest tricks is to make people believe he does not even exist. Heaven and earth a short distance and thin line between each other, with a wide path to wonder off of into hell when you are not watching where you step.

God loves all of his children, and all that call upon his name shall be saved. For by grace are ye saved through faith; and that not of yourselves:

it is the gift of God (Ephesians 2: 8). Nourishing your body and mind with God's word can replenish your weak and famine spirit with strength to fight off Satan's constant barrage of insults to the human psyche. We need the strength from God to keep us strong and keep us connected to the reality of life, and it's good and bad influences. You have heard of me speaking of the holistic approach to life; well this is a way in which you can review your life in different areas and see where you need to change some things. If certain things have been dragging you down here on earth, and has kept you from going in the right direction toward heaven's gate: taking a holistic approach to your life will let you see all aspects of your daily living that has brought you to this point on earth. As your journey here on earth unfolds, please do not forget to praise the Lord for giving you the wisdom and strength that he gives his children to find their way home to heaven. May God bless your journey.

FOUR

Butterfly Wings

How excellent is thy loving kindness, O God! Therefore, the children of men put their trust under the shadow of thy wings. They shall be abundantly satisfied with the fatness of thy house; and thou shalt make them drink of the river of thy pleasures. For with thee is the fountain of life: in thy light shall we see light, O continue thy lovingkindness unto them that know thee; and thy righteousness to the upright in heart. Let not the foot of pride come against me, and let not the hand of the wicked remove me. There are the workers of iniquity fallen: they are cast down, and shall not be able to rise (Psalm 36: 7-12). Butterfly wings are as delicate as we are in life. Each day we flap our wings in life we need the grace of God to keep us airborne in our endeavors as we reach out into the world to pursue our dreams and desires in life. As we grow stronger in God's word, our butterfly wings grow stronger. The metamorphosis of us as human beings is not unlike the butterfly wings as we grow into adulthood.

When we first venture out on our own as adults we are small, but have big hopes and dreams. We are weak, but strong in determination to succeed in life. Our butterfly wings flap vigorously in the beginning of our

journey as our life unfolds to reveal our goals in life. Each person we meet or encounter we have in life with others can determine how fast we fly with such a delicate essentiality to thrive as a human being. As we journey we learn life's lessons, and accommodate our flight pattern as such. No matter the direction of your flight, you must consider those around you and how life will not only affect you, but them also. This seems like a lot to ask at the beginning of any pathway we follow, and can seem too perilous to even think about at any given time in your life. As you grow older, you began to see the pattern of what goes around comes around. Life is a circle of events so watch out! The good news is that we have our Lord and savior to thank for any second chances we get, if only we believe in him who gives life.

We should put our trust in God, and under the shadow of his wings shall we go to great heights in his loving kindness. The most inspirational thing that we can do in life to keep our lives in perpetual motion is to trust in the Lord, that's all, just trust him. We have put our trust in so many people and things that have not been even worthy of such great belief, and have failed us so many times in so many ways. We must stop the madness and believe in the one who gave us life, for he is the only one that has shown his love and merciful kindness to all who worship him. Flap your butterfly wings, but do it under the safety and guidance of our father in heaven who wants to see your safe return home some day after you have finished your journey here on earth.

Somewhere in your lifetime it will appear that you have flown pretty fast through your life here on earth. This feeling hits different people at different ages. I like looking at the brighter side of life though, and that is to live and learn in a short life is better than not learning and living in a very long life. So do well with what is given you and make each flight daily with the intent of being someone you would love to be associated with in your life. God loves all of his children and he has blessed us in different ways. Use your blessing that was given to you by the Lord in a positive way so that your journey with butterfly wings can spread far and wide no matter how much time you have here on earth. Smile! God loves you! Always remember that. When we think back on our life of what we have done, or what we wish we had done we should always remember this: life is what you make of it, and you can change things at any given time you are not happy with it. Even with small daily changes things can be seen as a positive move in the right direction.

Changing your outlook on life and behavior is something that you have control over not Satan. Anything that you cannot control you can always get help with, but only if you want help. The choice is yours. Having a positive attitude is just the beginning of going in the right direction. How we treat each other shows our belief in God's plan for us. Jesus said that we should love the Lord thy God with all thy heart, and with all thy soul, and with all thy strength, and with all thy mind: and thy neighbour as thyself. Do this and you shall live. Our belief in God and how we interact with each other is a head start in the right direction on our life's journey.

For behold, the day cometh, that shall burn as an oven; and all the proud, yea, and all that do wickedly, shall be stubble: and the day that cometh shall burn them up, saith the Lord of hosts, that it shall leave them neither root nor branch. But unto you that fear my name shall the Sun of righteousness arise with healing in his wings; and ye shall go forth, and grow up as calves of the stall. And ye shall tread down the wicked; for they shall be ashes under the soles of your feet in the day that I shall do this, saith the Lord of hosts. Remember ye the Law of Moses my servant, which I commanded unto him in Horeb for all Israel, with the statutes and judgments. Behold, I will send you Elijah the prophet before the coming of the great and dreadful day of the Lord: And he shall turn the heart of the fathers to the children, and the heart of the children to their fathers, lest I come and smite the earth with a curse (Malachi 4:1-6).

Keep flapping your wings in the direction of the Lord's light so that you may see the direction in which you are going in. For when you are in the dark, you cannot see where you are going, and this is a good time for Satan to entrap your body, mind, and spirit into a foolish life of thinking that you know better than God does. Look around you; if we know better, shouldn't we be doing better. Calling out for the Lord's help shows our love for him and our need for his guidance. This is not a weakness, but strength to show courage and determination that you want to go in the right direction, and when you do resist Satan, he shall flee from you. A life long journey traveled on this earth can be an education in itself, but you need the help of God to maneuver through life like a child of his with grace and composure.

So flap your wings you children of God, but avoid things that will only corrupt your body, mind, and spirit which will leave you with a feeling of hopelessness, guilt, and despair in the end. When a person has

no remorse for his unholy deeds, then you can say you have looked at one of Satan's emissaries straight in the eye and you were able to fly away under the shadow of God's wings to a safe haven that he has prepared for us in heaven. Keep your faith strong in the Lord and he will not forsake you. You need to believe in him to receive his blessings, so stay strong in your faith in him who loves all his children in this world we live in, and love one another for we all seek love, need love to flourish. When you let Satan reign over your thoughts and deeds your wings are clipped and you can no longer fly with the grace of God as your savior. This will leave you hell bound with no possibility of being a flight risk. Let love be without dissimulation. Abhor that which is evil; cleave to that which is good (Romans 12: 9).

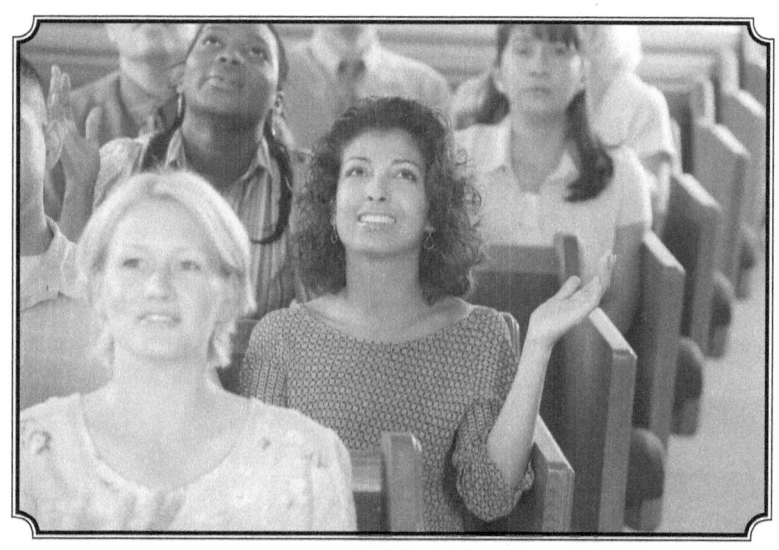

FIVE

Color of Love

We are of God: he that knoweth God heareth us; he that is not of God heareth not us. Hereby know we the spirit of truth, and the spirit of error. Beloved, let us love one another: for love is of God; and every one that loveth is born of God, and knoweth God. He that loveth not knoweth not God; for God is love. In this was manifested the love of God toward us, because that God sent his only begotten Son into the world, that we might live through him. Herein is love, not that we loved God, but that he loved us, and sent his Son to be the propitiation for our sins. Beloved, if God so loved us, we ought also to love one another. No man hath seen God at any time. If we love one another, God dwelleth in us, and his love is perfected in us. Hereby know we that we dwell in him, and he in us, because he hath given us of his Spirit (1 John 4: 6-13).

To love God we must love each other. How can you love God whom you have not seen, and hate your brother, this makes you a liar. If you do not love your brother whom you have seen, how can you love God who you have not seen? We are all God's children no matter our color, creed or ethnic group. We choose to love people by their looks, and status in

this world, or just simply their race. Judge not, less thy be judged. God has his reason for making us all so different, but the same in this world. Some people have figured this out already, and some have not. I personally think that if every person we met in this world were someone we liked, then there would be no challenges to life that shows God that we can love him because we love each other. When we start to pick only the qualities we like in a person this limit's our potential love for each other. You can actually learn to love every one when you see them as a human being like yourself, and not someone that you have to match up with in life.

I know some people you meet will have the most annoying personality to get alone with, but we do have the power of prayer to help us to help them and ourselves in these situations, and sometimes we will have to just walk away, regroup and come back another day. We are all humans who can make mistakes in this world, but who are we to judge each other for we will have to answer to God one day for our own iniquities in this world, and should not have to help someone else pay for their sins by joining in with them and their sinful ways of living. Think about it, do you not have enough on your own plate? Clean your own plate, and look to the Lord for trying to keep it clean. You will not meet perfect people in this world so deal with the thought of not all great minds think alike (smile). Children of God are never alone; he is always at our side to guide us in our endeavors.

Hatred stirreth up strifes: but love covereth all sins (Proverbs 10:12). The Lord loves us and just ask that we love each other. He is not asking for material things from us, just something that we can give from the heart. Trust me I know that you know this can be very difficult at times, but we have to at least try so the Lord will know from our heart that we have at least tried to put forth his teachings while we are living here on earth. I know some people have selective hearing and sight in this world, and can only comprehend only the things they want to understand when it comes to loving one another, but when you love God you know that there is a reason for everything, and everything will be revealed to us; his plans for us are to help guide us and protect us from the lures of Satan who is just waiting in the shadows for our demise to claim our souls for himself.

When I was a very young girl, I had a playmate by the name of Mary. We played together often, and it was never mentioned that I know of that, she was white and that I was black, and that we should not play together. In fact, almost all the kids on our block played together. May we be in

their yard or ours, we all played together, and I cannot remember any negative words coming from her parents or mine that we could not play together. I remember when her father would walk us to the store and buy us both popsicles in the summertime. He would walk between us both at his side, never a negative word did I ever hear him say. All that I can remember of him is that he appeared tall to me, and that he was a nice and gentle person. When they moved away, of course I never heard from her again. I never knew where she and her family moved to. This was in the late fifties in the south. I can remember the good and bad of living in the south, but there is one thing that I will never forget is the people I met who liked me for myself, and did not care that I was of a different color. They saw and treated me as any other person in this world as God does. The innocent of childhood is the color of love.

Some of us grow cynical as we grow older, only because our experiences have shape our mindset. People know two things concerning life. What they have learned from others, and or their own true experiences. Some people cannot get beyond either, and let life breath on its on accordance: acknowledging the good and bad in people, but not letting it control the love they can have for another person. I do not think that God put us together so he could see us go at each others throat. I believe he had a much better plan in mind. A harmonious one. God would not put a mix like us together unless he knew it could work. I personally think we give Satan too much power when we let him control our thoughts and deeds. Because thy lovingkindness is better than life, my lips shall praise thee (Psalm 63: 3). We should praise the Lord for his love for all humankind for which he gave his own life so that we may live in peace together in his father's house.

The color of love is colorless in the eyes of God. He see us as his children, and loves us as any loving parent would love their child. I do not think God is sitting on his throne thinking why did I create those black people, or those white people, or those brown people, or yellow people, or those little green people, ha ha got you. God does not make mistakes, we do. The only one we can blame is ourselves when we listen to Satan and not God. Have you ever notice how much you will put up with when it comes to someone you really love? Others have. Now that we have established that love is colorless, and blind. Oh! and do not forget love has a sense of humor also. Do not tell me you have never notice?

Why do you think it is better to have loved and lost, than never to have loved at all? I imagine a person who only loves him or herself suffers a multitude of agonies within his or her soul because there is no greater feeling than to love, be loved or to feel loved in this world; and to get love you have to give love as we all know. Some people will not let you get close enough to them to love them, but everyone has a weak spot, you just need to know where it is without compromising your own beliefs in God. Do not confuse love and lust, which are two completely different things. Jesus asked that we love one another. He knew this would be the bridge to our salvation, because without love there is no salvation for us who claim we love the Lord. We could not live if not for the love that God has for us. The color of love is colorless my friends.

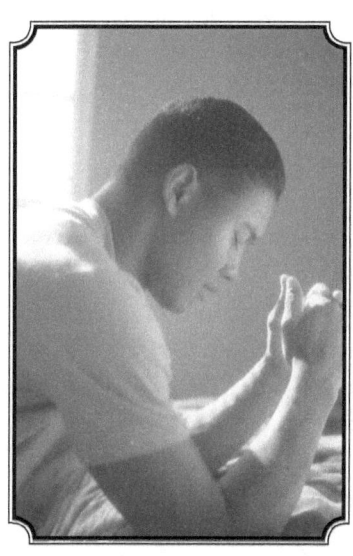

SIX

Sacred Moments

Sacred moments are the times when you can devote your time to worshiping God and thank him for blessing you with life, and the understanding of his word. And all things, whatsoever ye shall ask in prayer, believing, ye shall receive (Matthews 21:22). There are times when we are alone and should use our quiet time in supplication to our Lord and savior. These moments will help to replenish our famine spirit that can be depleted just from living everyday life. Fellowship with others who believe in God and his given word to his children will help strengthen your will and testament for this shall be your stronghold to your faith. When Jesus died on the cross the shedding of his blood saved us from eternal damnation. What a heavy price to pay for all humankind to show how much he loves us. We love him, because he first loved us (1 John 4: 19).

A person who lives in this world can either follow in the footsteps of Jesus Christ teachings for the salvation of their soul, or follow in the footsteps of Satan suicide plan. Those who live by the ways of the world will only be left with remorse, and the sorrowfulness of a torture soul. To live by the word of God will give your mind, body and spirit peace now,

and forever. The sacred moments that you give to prayer will help to keep you sane and on track with God's word and his word will always help to nourish your spirit. A person should give thanks to the Lord everyday for him giving them the strength to carry on in their daily lives. We need the love, mercy, and grace of God everyday. Those who think they can get by without giving thanks to the Lord for what he has given them will see a lot of strife, confusion, deceit, and false hope in their endeavors. Satan will always creep into your mind to try to oppress your sense of goodness: dismiss his instructions and follow the path of the Lord's light.

Time spent renewing your spirit will help seal your faith in God's word when you show repentance, and faithfulness to the one who has brought you to this point in your life. Prayer is a powerful source of energy that can spread far and wide when we believe. When you use your sacred moments to praise and thank the Lord your days are more comforting and reassuring when you go about your daily activities of living in this world full of strife, and condemnation. What we must understand is that life will not change as we know it, just the way we perceive it. This will help to soothe the mind and spirit when you not only believe in God, but also live by his word. Some people learn wisdom at an early age, and some when older, and that through the mercifulness of our Lord and savior, and only through him, can we grow stronger in patience, love, and understanding of our purpose here on earth as a child of God.

This Psalm of David will enlighten your path: The Lord is my shepherd; I shall not want He maketh me to lie down in green pastures: he leadeth me beside the still waters. He restoreth my soul: he leadeth me in the paths of righteousness for his name's sake. Yea, though I walk through the valley of the shadow of death, I will fear no evil: for thou art with me; thy rod and thy staff they comfort me. Thou preparest a table before me in the presence of mine enemies: thou anointest my head with oil; my cup runneth over. Surely goodness and mercy shall follow me all the days of my life: and I will dwell in the house of the Lord for ever (Psalm 23: 1-6). As your faith grows stronger so will your strength and understanding. Perseverance is your stronghold so use it to its fullness, and watch your days turn to enlightenment in the direction you should be traveling. Being justified by faith, we can have peace with God through our Lord Jesus Christ.

This gives us access by faith into his grace, which gives us: hope to rejoice in the glory of God. Each and every day can be a struggle when

you do not have a clear path or do not understand why things happen the way they do. Sin was brought into this world by us, and sin is what keeps us troubled. When you listen to the Lord's word; your world of struggling day to day is enlighten with knowledge of knowing how to handle people who will try to engage you in the destruction of the mind, body, and spirit. Let the Lord's word guide you through life, not Satan or his emissaries. I know sometimes we can get caught up in every day life problems that we tend to forget the direction we should be going in when detraction takes us off our designated true path, but every attempt to stay on track does not go unseen by God.

Do not stagger in disbelief of God's promise to us; but stay strong in faith, always giving glory to God. For he hath delivered me out of all trouble: and mine eye hath seen his desire upon mine enemies (Psalm 54: 7). Sometimes you may notice that people will not accept the truth of the Lord's word as gospel. Save me, O God, by thy name, and judge me by thy strength. Hear my prayers, O God; give ear to the words of my mouth. For strangers are risen up against me, and oppressors seek after my soul: they have not set God before them. Behold, God is mine helper: the Lord is with them that uphold my soul. He shall reward evil unto mine enemies: cut them off in thy truth (Psalm 54: 1-5). The Lord is always with you, and he will never forsake his children. We are the one's who do not have faith in his word. Sometimes it is a simple thing, like when things do not go our way of how we think things should be in our lives.

In my first book I talked of realization of where you stand in your life. This realization can help you move forward, backward or leave you paralyzed in your steps. Each person takes their own journey in life in the direction they feel comfortable with. Some people will stay blind to the truth until they believe in the truth. So they will not comprehend any message of God to be the truth of how we should live our life. They will see every thing in his message, but the truth, for they are blind to his word. It has always amazed me how we can sometimes make life more difficult than it has to be. Some people say life is complicated: The complications I have seen in my life were always man-made, or self made. Have mercy upon me, O God, according to thy lovingkindness: according unto the multitude of thy tender mercies blot out my transgressions. Wash me thoroughly from mine iniquity, and cleanse me from my sin. For I acknowledge my transgressions; and my sin is ever before me (Psalm 51: 1-3)

Look into your heart when realizing where you stand in this world, and where your contribution to life on earth lay. Pray for yourself and others so that we all may have the Lord's blessings bestow upon us. Sacred moments should be used to glorify God, and to accept his word as truth for our well-being to prosper in life. Notice when you use your time wisely how things flourish for the betterment of self and others. If you feel like your life is complicated then review your life, and make changes where it need be. The complication I see in life comes from not following the truth in the Lord's word. I believe if you do the best you can with what you have been given in life, you can never be a failure to God, for your deeds do not go unseen by the Lord's eyes. Brethren, if any of you do err from the truth, and one convert him; Let him know, that he which converted the sinner from the error of his way shall save a soul from death, and shall hide a multitude of sins (James 5: 19-20).

SEVEN

The First 63 Years

When my life began here on earth sixty-three years ago I had no conception of being a child of God. My thoughts of self and others grew in different directions as I grew. Only after experiencing life with others for a long time did I realize my true destination. Maybe God presents himself early in some people's lives, but in mine he was there only in hearsay until I really began to notice his work. What I mean by this is when I called upon him, or confessed to be a child of his, only then did I began to see the miracles he had done for me to keep my belief of him alive in my spirit, heart, and in my life as a child of his. As a young person I came to God as some people do only when they felt that they needed his help. At other times I went in search of life on my own without asking God for his guidance. A false happiness that took some time for me to see. Lives that blossoms in God's word shall be free of fear come the day of reckoning.

There is therefore now no condemnation to them which are in Christ Jesus, who walk not after the flesh, but after the Spirit. For the law of the Spirit of life in Christ Jesus hath made me free from the law of sin and death. For what the law could not do, in that it was weak through

the flesh, God sending his own son in the likeness of sinful flesh, and for sin, condemned sin in the flesh. That the righteousness of the law might be fulfilled in us, who walk not after the flesh, but after the Spirit. For they that are after the flesh do mind the things of the flesh; but they that are after the Spirit the things of the Spirit. For to be carnally minded is death; but to be spiritually minded is life and peace. Because the carnal mind is enmity against God: for it is not subject to the law of God, neither indeed can be. So then they that are in the flesh cannot please God (Romans 8: 1-8).

As we mature in our mind, body, and spirit life should have taught us of the pitfalls of the flesh, but to some, they do not see this as a problem to overcome in life, and some will always have the belief that gratification of the flesh is more satisfying than the belief that if we trust in God we will have eternal life, not death. Those who say they believe in God, but do not live by his word will perish. Being a good person is being lukewarm to God, for you are neither here are there with the salvation of your soul. Be reconciled to God; for he sent his only begotten son so that we may be saved and receive his grace. God is our father, we are his sons and daughters who live and thrive through his mercy. Let us not forget the blessings that he bestows upon his children each and every day so that we can love him as he loves us always. Make a decision in which direction you want your life to go in; so that each day you can walk in the light.

My only regret in life was that it took me so long to understand what God was telling me through my whole life, but that I could not hear or see because of wanting to walk after the flesh. Trying to live by worldly ways of gratification can leave a bad taste in your mouth at the end of the day, and a lost soul at the end of your life here on earth. We must wake up to the pitfalls that can consume us in ways that will lead to our demise. When Satan greets you at the door to eternal damnation, it will probably, most likely be too late to wish you had done things differently. Oops will be a word for the still living, not the damned. My rule of better late than never does not apply to this situation my sisters, and brothers. Love life, and live it as a child of God. Life will teach you many things in so many different ways; not to hurt you, but to help you grow stronger in the knowledge of the life before you.

If people could see their future, a future that has been determined by their past and present way of living. If they could see that far ahead do you think they would change their way of living now, or believe that

the way their life is now is just fine, and they see no need in making any changes in their life. Oh, because that's the way of the world, and it is what it is. It is what it is, not because it has to be, only because to change things for the better takes work in a world of chaos. Most people are not up for the challenge, but as I see it, if each person changed their way of thinking for the betterment of society, they would change the world. Trust me when I say if I had known in my early years what I know now which is still very little in the scope of life, I would have chosen my steps much more carefully in my first sixty-three years of living. You cannot go back to the past, but you can go forward to a bright future when you have faith in your Lord and Savior Jesus Christ who leads the way to your salvation here on earth.

A follower of God will seek his love, and live for the spirit, I do believe this. A follower of Satan will seek in the world the things which gives them worldly satisfaction, because they live for the flesh, I do believe this. Say what you may, but what way would you say beareth the best fruit. How I live the rest of my life on earth will be a pleasure unto my heavenly father's teachings. If I fall or flounder I will get up and try again. A life lived in sin with no remorse, is the life of a spiritually blind person who is destined to find him or herself in the clutches of Satan's grip if they cannot see in their minds eye the light that leads them to God. Life does not all of a sudden change when you change, it's a gradual progression toward the light, and if you choose to move toward the darkness it will accumulate into a life showing what or who you love the most. The goals you have in life should be reflected in the way that you live your life.

The Lord is far from the wicked: but he can hear the prayers of the righteous. Be faithful, and patience for the coming of our Lord Jesus Christ draws near. The Lord is not slack concerning his promise, as some men count slackness; but is longsuffering to usward, not willing that any should perish, but that all should come to repentance. But the day of the Lord will come as a thief in the night; in the which the heavens shall pass away with a great noise, and the elements shall melt with fervent heat, the earth also and the works that are therein shall be burned up (2 Peter 3: 9-10). Be wise to the words of the Lord for he always keep his promises. To those who do not believe; they will not see the new earth or new heaven where the righteous shall dwell. Do not be led away by the wickedness of humankind, but stay steadfast in your faith in God who shall free you from the bondage in your mind, body and spirit.

Rebuke Satan, live in the light of the Lord, and be merciful, as your father also is merciful. Judge not and you shall not be judged, forgive and you shall be forgiven. Condemn not, and you shall not be condemned. Give and it shall be given unto you. Blessed is the man that endureth temptation: for when he is tried, he shall receive the crown of life, which the Lord hath promised to them that love him (James 1: 12). When I pray my days settle well in my heart, and as I go about my way in this world I feel hopeful of the things to come, knowing that God loves me, and is forever at my side giving me the strength to live each and every day, day by day. Endurance has become second nature in my soul; I will not be defeated by Satan, and will not give up my love for the Lord. He has been with me all of my sixty-three years. I will endure simply for the love and peace that he gives me.

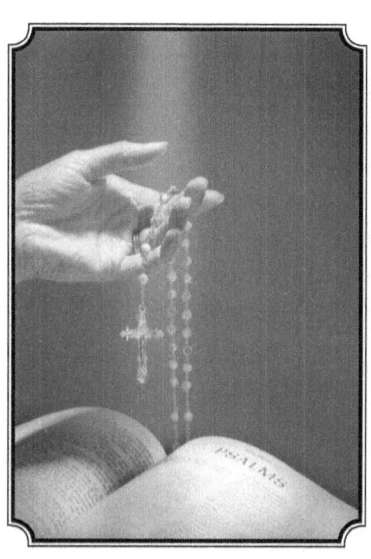

EIGHT

By the Grace of God

Even the righteousness of God which is by faith of Jesus Christ unto all and upon all them that believe: for there is no difference; For all have sinned, and come short of the glory of God; Being justified freely by his grace through the redemption that is in Christ Jesus: Whom God hath set forth to be a propitiation through faith in his blood, to declare his righteousness for the remission of sins that are past, through the forbearance of God; To declare, I say, at this time his righteousness; that he might be just, and the justifier of him which believeth in Jesus. Where is boasting then? It is excluded. By what law? of works? Nay: but by the law of faith. Therefore we conclude that a man is justified by faith without the deeds of the law. Is he the God of the Jews only? Is he not also of the Gentiles? Yes, of the Gentiles also: Seeing it is one God, which shall justify the circumcision by faith, and uncircumcision through faith (Romans 3: 22-30).

By the grace of God by faith of Jesus Christ are we saved. This is a powerful, most true statement that we as Christians can base our existence on. This is a simple rule that we can believe, and trust in God's word when we believe in his love for all his children. A child of God has

only one road to travel down, which keeps confusion at bay. The love of God is what helps us to keep our journey on the path of righteousness free of worldly clutter. Venturing out on your daily journey should be done with the knowledge that you are a child of God, because you have faith in Jesus Christ as your Lord and Savior. All the things that are going on today in the world will come to pass, so the only true thing you can hold onto is your faith of redemption for your sins, and know by your faith that you will be saved in the day of judgment. All things are possible with God.

Draw yourselves close to God, and he will draw closer to you. Submit yourselves to God, and resist Satan, and he will flee from you. Humble yourselves in the sight of God and purify your heart. God resist the proud, but gives grace to the humble. Speak no evil of one of another; judge not. There is only one true judge. Grow in grace, and knowledge of our Lord and Savior Jesus Christ. Let us therefore come boldly unto the throne of grace, that we may obtain mercy, and find grace to help in time of need (Hebrews 4: 16). If we believe there is a God; then we should be obedient to his word. We should seek, worship, praise, and trust him all the days of our lives to receive grace and mercy from his loving kindness to his children. Times are hard and our days are long when we cannot see the things God has shown us, but when our mind, body, and spirit is enlightened to God's word: life is much more comprehensible to why things are what they are in this world.

We should sanctify God in our heart, so when we are asked by others we can give a reason for our hope, only being a good steward to the manifold grace of God: if we commit our souls to God. Blessed are they that do his commandments, that they may have right to the tree of life, and may enter in through the gates into the city (Revelation 22: 14). When we believe in God, we show our love for him, never fearing what others may think of us. Jesus once said if we deny him before men, then he will deny us before his father: can you honestly live with that thought? I cannot, and I'm sure that those who know that they cannot live forever cannot either. We must keep ourselves in the love of God, looking for his mercy all the days of our lives. May the grace of God be with us always.

Grace is a virtue from God that gives us acceptance and forgiveness for our sins. Through his grace can we live free of the bondage that has enslaved our body and mind of worldly situations that have punished our souls for being imperfect, a hole that we can come up out of by the grace

of God. When we live in the light of God's grace, we can grow stronger each day that we journey forward on life's path that lay before us on our daily endeavors. Keep in mind that each day can be a struggle and any attempt you make to stay on track with God's word will help strengthen you. Perseverance leads to endurance, and a stronghold on your believe in God's word. It is not hard to live by the word of God when you are not a slave to Satan's lies and deceptions. Our bodies can be weak only when we forget who truly loves us. Fight the battles and win the wars of iniquities that you come up against daily to help save your eternal soul.

To receive the grace and mercy of our heavenly father's love we should obey him. He asks very little from us, but gives us his promise of eternal life if we obey him, and have faith in his word. All of Satan's promises are full of lies and deceit, and not one person who has ever followed the path that he had put before them came to any good in this world. Whatever thoughts Satan puts into your head is bad for you, but good for him if you listen to what he says. His trickery is paramount, and he knows your weaknesses well, for that is how he traps you into believing his lies. But be fearful, and unbelieving, and the abominable, and murderers, and whoremongers, and sorcerers, and idolaters, and all liars, shall have their part in the lake which burneth with fire and brimstone: which is the second death (Revelation 21:8). God said he that overcometh shall inherit all things. I ask that you grow in grace and in the knowledge of our Lord and Savior for your salvation.

Satan is said to be very charismatic, but he will truly lead you in the wrong direction in your life. God wants to open our eyes to this darkness and turn us from the darkness to the light; so that we may receive forgiveness for our sins. Jesus once said get thee behind me, Satan: thou art an offence unto me: for thou savourest not the things that be of God, but those that be of men. When your thoughts try and lead you in the wrong direction just say get thee behind me Satan I am a child of God, and really mean it, and watch him disappear out of your thoughts, and when he does your thoughts will be yours again. Sin shall not have power over you, because we are under the grace of God. But if we walk in the light, as he is in the light, we have fellowship one with another, and the blood of Jesus Christ his Son cleanseth us from all sin (1 John 1:7).

We must repent from our sins, receive Jesus Christ, and we must obey and love him. (Now go tell others). Whosoever therefore shall confess me before men, him will I confess also before my Father which is in heaven.

But whosoever shall deny me before men, him I also deny before my Father which is in heaven (Matthew 10: 32-33). By faith you must open your heart and your life to Jesus Christ. Believing and trusting in him. Behold, I stand at the door, and knock: if any man hear my voice, and open the door, I will come in to him, and will sup with him, and he with me (Revelation 3:20). By grace we are truly saved. Open the door and let him into your heart, and see your life transform into everlasting peace. You will surely view life differently when God is in your daily life. A child of God is never alone; God never leaves his children unattended, but watches over them as they soar to great heights with his love in tow.

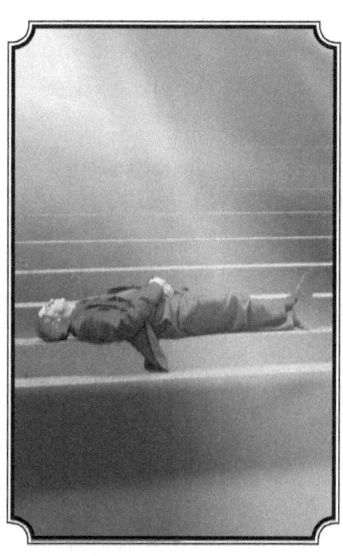

NINE

Healing

In the midst of the street of it, and on either side of the river, was there the tree of life, which bare twelve manner of fruits, and yielded her fruit every month: and the leaves of the tree were for the healing of the nations. And there shall be no more curse: but the throne of God and of the Lamb shall be in it; and his servants shall serve him: And they shall see his face; and his name shall be in their foreheads. And there shall be no night there; and they need no candle, neither light of the sun; for the Lord God giveth them light: and they shall reign for ever and ever. And he said unto me, These saying are faithful and true: and the Lord God of the holy prophets sent his angel to shew unto his servants the things which must shortly be done. Behold, I come quickly: blessed is he that keepeth the sayings of the prophecy of this book (Revelation 22: 2-7).

God loves his children, and so these are the things he showed John to reveal to us what laid ahead for his children who remained faithful to the end. Like I have said before when you believe and trust in the Lord, this does not change the way life comes at you, may it be good or bad. What your belief and trust does is help you deal with the bad and good in a

way that your decisions are based on having more clarity of the situation at hand; The what, and why of dealing with the when. The healing of your body, mind, and spirit is a lifetime of hit and misses. Do not be discouraged by the misses, but keep going for the hits. That's life, so do not give it up to Satan; because he will always be knocking at the door until the end. As your strength grows, so does your determination. God wants us to enjoy our lives in a way that is fruitful to us and others so do not be the person that drags other down, but be uplifting to all you meet, and you will be uplifted as well.

The believers, and non-believers will be separated one day soon. Imagine what it will be like to be on the believer side, and keep this positive thought in your head. Healing is a process, not something done overnight unless you have been touch by God in your dreams, or near death experience as some have been in times past and present. To believe is to understand, and to understand is to be obedient to God's word. Just remember to say get thee behind me Satan, for I am a child of God, and he will flee from you. God will keep all his promises to his children; always remember this in your heart. When you wake up in the morning be thankful, and when you go to bed at night be thankful to God your heavenly father for allowing you to make it through the day. Each day is a day of healing that has been granted to you by God. Give all your praises to Jesus Christ your redeemer for through him are we saved.

On a mountain top Jesus taught his followers many things (Matthew chapter 5-6-7: verses 1-48.1-34, 1-27). Read his words so that you may understand what is expected of you on your journey in life. And when you do understand you can begin your healing process knowing in which direction you should be going in. When you make a decision to live in the light of Jesus words, your hope will be magnified by God's promises to all who listens and obey. Have mercy upon me, O Lord; for I am weak: O Lord heal me; for my bones are vexed (Palms 6: 2). I speak these words because I do believe in God's promise, and I need his help in keeping my promise to love and obey him. Remember Jesus' words enter ye in at the strait gate: for wide is the gate, and broad is the way, that leadeth to destruction, and many there be which go in thereat: Because strait is the gate, and narrow is the way, which leadeth unto life, and few there be that find it (Matthew 7: 13-14).

As we go through life we learn many different things. Things that can help or hinder our well-being here on earth. Sometimes we are push into

a corner by people who gives us no choice but to fight or flight. How we handle every day situations can be an ongoing struggle to survive in a world that is bent on worldly aspirations and not God intentions on the way he planned for his children to live. Some days are a test of skills between ours and Satan's, who will win the showdown? The best way to foresee a disaster is to know that when you are dealing with life, you are dealing with many variables. This alone can and should keep you on your toes, however sometimes when we are caught off guard, not because we let our guard down, but because we let Satan rule our sense of reasoning and retaliate with a response unbecoming of a child of God. Get thee behind me Satan (repeat these words over and over to yourself for as long as it takes for you to gain your composer). Remember healing is a process that takes the soul on a daily journey.

To heal our soul is to restore our true destiny in life, which will keep us on track to partake of the blessings that God has planned, and prepared for us in heaven. To live the life of a child of God is a journey of great endurance, but most rewarding. For those who do not believe in God's word they will not be spared the reality of what it means to be separated from his love for an eternity. The children of God will feel the reality of his love for eternity. The love of God is what leads his children down the road of eternal life free of worldly strife. When you pray for healing ask and you shall receive. No provision are made for the unworthy who seek not the face of God, but seek refuge with the wrong doer's of life. When you indulge in worldly pleasures that do not please God, this will lead you in the direction of Satan; because each step will bring you closer to him, and further from the father, and the sad thing is that you will have not notice how deep you have sunk into your pool of iniquities until it is way to late.

Open your eyes do not be blind to the Lord's word. Some people seek quick gratification in their short existence here on earth. Thinking it's okay to be materialistic, or over bearing to others, hey that's the way of the world. Yes they are right, that is the way of the world; but not the way God wants us to live our life, and treat others if we expect eternal life in the light of his presence. My motivation, inspiration for anyone who reads my words is that to know that God loves his children, and is always at their side. Do not be afraid to do what God ask of you, and do not get sucked up in the belief that because a certain thing is the way of the world that you can and should do this too. Do unto others as you would have them

do unto you; will always lead you in the right direction of the Lord's light. Remember if you deny Jesus now, he will deny you before the father later. Can you really live with this thought that you are denying your redeemer that died on the cross for you in the most horrific way to save your soul? You can live by his word, just by taking life one day at a time.

Work on your iniquities, you know what they are in this world. Do not think just because everyone is doing this, that it is okay. Because if everyone else is doing this, it just means that everyone else will be joining you in the lake of fire; this is not consoling in the lease bit. God does not ask much from us, and he can help us with what he does ask of us. Improving your body, mind, and spirit helps with the healing process. Enlightening yourself to the process of healing is what will make your time here on earth more fruitful to you and others. Use the tools that God has given you in a good way befitting a child of his in this world. God knows where your weaknesses are and he can help you to grow stronger when you put forth the effort to try and better yourself in his word. Most people feel like they have plenty of time to get right with the Lord. They think I am still young, and I am in good health, and I am not worried for I am a good person. When it is time, it is time and none of these factors matter when it's time. Start your healing now, enlighten yourself.

TEN

Power of Love

There once was a young woman whose mother cherished her love, for she was a good daughter in her mother's eyes. She had her ups and down's as any person would have in their lifetime as her mother had also in her life. The power of love for each other is what kept the bond strong. The power of love works through many storms in a person's life, and weathers well into a comfortable way of living. When we love one another in life may it be family, friend or foe, we love that person as another human life here on earth that God himself has created in his own image. This continuing love for one another can transcend into the power that love can overcome a multitude of sins as does charity when given in earnest belief that we should love at all times. There is no fear in love; for the person who loves God loves his brother also. God is love for he is the only one that can give you eternal life.

But I say unto you, love your enemies, bless them that curse you, do good to them that hate you, and pray for them which despitefully use you, and persecute you; That ye may be the children of your Father which is in heaven: for he maketh his sun to rise on the evil and on the good, and

sendeth rain on the just and on the unjust. For if ye love them which love you, what reward have ye? Do not even the publicans the same? And if ye salute your brethren only, what do ye more than others? Do not even the publicans so? Be ye therefore perfect, even as your Father which is in heaven is perfect (Matthew 5: 44-48). God commands us to love one another for he knew that the world hated him before it hated his followers who believe in his word which speaks of salvation for those whom follow in his footsteps.

Let God's love for you shine through to others and your life shall be enlightened with the blessings of his love. Loving someone with kindness will not lead you to a darken place, but a place of love and light. Read your bible and you will find the answer to what you need to do to be a child of God. The answers to your questions are in this book, not in the worldly ways of humankind. When Jesus died on the cross he gave up his life on earth at a young age just so we could be saved and have eternal life in heaven with God and all of his other children. He paid a huge price for our souls and we should never forget such a great sacrifice that he made so that we could live. There is no other person in this world that has made such a great sacrifice as he has for our salvation in the past or present time. Life can, and always will be most difficult at times, but always remember his love for you, and keep this foremost in your mind.

God that made the world and all things therein, seeing that he is Lord of heaven and earth, dwelleth not in temples made with hands; Neither is worshipped with men's hands, as though he needed any thing, seeing he giveth to all life, and breath, and all things; And hath made of one blood all nations of men for to dwell on all the face of the earth, and hath determined the times before appointed, and the bounds of their habitation; That they should seek the Lord, if haply they might feel after him, and find him, though he be not far from every one of us: For in him we live, and move, and have our being; as certain also of your own poets have said, For we are also his offspring (Acts 16: 24-28). These verses let you know that God is close at hand always, and we are the one's who distance ourselves from him, and not him from us his children.

When we keep our love, faith, and trust in God; life takes on a different meaning as a child of his. Children may wonder off, but not too far in this world that they cannot find their way back home to the heavenly Father who truly loves them; this is the power of love. As we grow we learn the power of love from family, friends, and others we might meet in life who

have helped us alone the way. All of this love that was directed our way that which has kept us from going off the deep end was done from heaven up above from the Father who works through his children for the good of all those who believe, trust, and love him. To help each other is the power of love, to have peace within yourself is the power of God's love for you. Each step that love makes puts us closer to the one that loves us the most in this world, God.

The young women whose mother cherished her love knew that her daughter's love for her was a blessing among blessings that every mother might not have in this world; in a world that God felt like she was deserving of, and wanting to let her know that he knew what was in her heart, and it is good. When we love all is right as rain: when we all love our neighbor as God has commanded us to do. When there is hatred, and strife in our life, there will be pain, may it be self inflicted or put upon you by others. God knows this, and that is why he has taught us that we should love thy neighbor, and if we did, there would be a difference in the outcome of every day we live here on earth. The power of love is great in so many ways when it is pleasing to God, for it has no boundaries of how far we can reach out to others we meet in our life long journey here on earth.

The power of love will never take you to a dark place when it is sanctified by God, and not by worldly desires that Satan has put in your thoughts of what love should be. A good way to tell the difference is when love is from the heart, and not from the lustful thoughts of the body. The love of God should be strong in our hearts, and mind so that our souls will be delivered from the grasping hands of Satan who tries to reach out and touch us at any given moment that he can during our day. Abstain from fleshly lust, which war against the soul. The bible teaches us all we should know about the love that God expects of his children, and the path we should take that love in our journey. There will and always will be people that know matter how nice and kind, and positive thinking you are toward them, they will always be negative to any good response you give. This is the road they choose to take, and should not deter you in your love for another human being.

May God bless those who read his word and obey. He knows your heart, and you cannot fool him as you do others in life. We are all human, and can be forgiven, if we forgive those who trespass against us. Remember love has no known boundaries for we are all God's children. And any child of his will persevere through many storms to be close to the Father who

truly loves them. If you love God first, then the love of others will come naturally in your life. Not everyone you have brotherly love for will have the same for you, but it will show God that you want to be among his children that he calls upon on that special day when we all go home. Live your life in truth, for the truth shall set you free from the bondage in your mind, body and spirit. Please take your journey down the path that God has shown us in his word, and the grace of God shall follow you all the days of your life. As always may God bless you, and keep you safe in his eternal love that he has for all his children.

The Beginning.

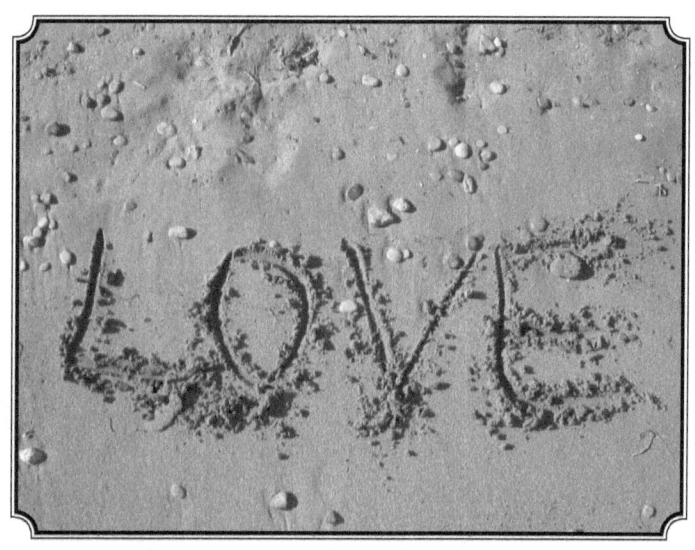

LOVE

Love is a life that should be shared with others.
When you love you bless another; love is good
when shared with others. God loves you because
you have shown love to another.

Love is a gift that we give to each other; that shows
we care for one another. Live your life with love,
and see your life open up to other pleasures. We
who love, have love for one another.

Love is a great inspiration for those who believe
in Jesus as their savior, and live their life to the
fullest depth of trial and error; in hopes of a better
today and tomorrow when we show love to another.

<div style="text-align: right">Lillie Sandridge-Hill</div>

www.ingramcontent.com/pod-product-compliance
Lightning Source LLC
Chambersburg PA
CBHW021044180526
45163CB00005B/2282